M000207015

Within National Parks is room—glorious room—room in which to find ourselves, in which to think and hope, to dream and plan, to rest and resolve.

—ENOS A. MILLS

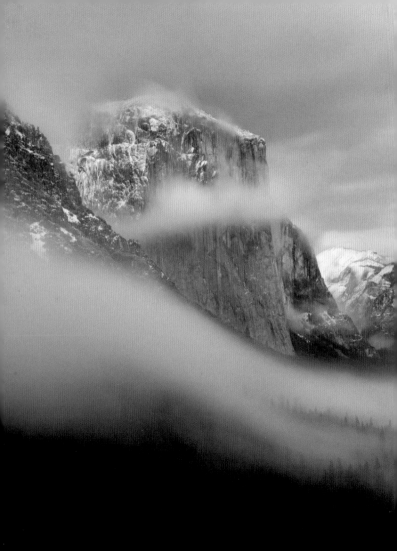

Tenth Anniversary Edition

Yosemite Meditations

PHOTOGRAPHS BY MICHAEL FRYE
EDITED BY CLAUDIA WELSH AND
STEVEN P. MEDLEY
FOREWORD BY MIKE TOLLEFSON

YOSEMITE CONSERVANCY
YOSEMITE NATIONAL PARK

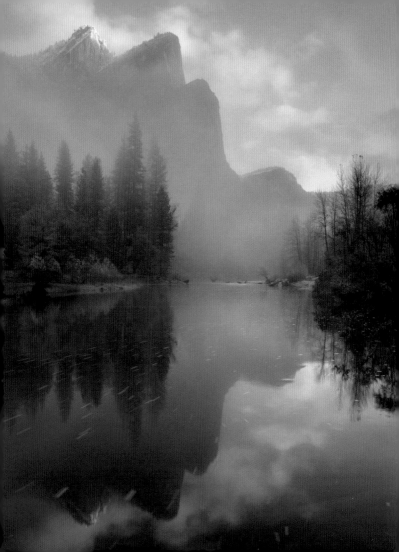

FOREWORD

Awe-inspiring granite cliffs, thundering waterfalls, magnificent giant sequoia trees, spectacular wilderness: Yosemite. It is not just the physical attributes that make Yosemite revered around the world; it is the spirit of the place.

In 1864, in the midst of the Civil War, it was that spirit that led Abraham Lincoln to sign an unprecedented act, the Yosemite Grant, which set aside the Mariposa Grove of Giant Sequoias and Yosemite Valley as the nation's first protected areas. It was that spirit that planted the seed of an idea, that our nation's most magnificent and sacred natural places should be, as Dayton Duncan writes in *Seed of the Future*, "preserved for everyone, and for all time." After a visit to Yosemite with John Muir, it was that spirit that further motivated President Theodore Roosevelt's extraordinary conservation efforts.

It is that spirit that has enthralled us since the first peoples lived in Yosemite. Yosemite inspires. It is a refuge. It is exciting. It is restorative. It is spiritual. The list is long and it is as individual as each visitor. *Yosemite Meditations* provides us with the opportunity to see Yosemite through another's lens and to experience Yosemite through others' reflections. This book is an opportunity to connect and reflect with Yosemite.

MIKE TOLLEFSON
PRESIDENT, YOSEMITE CONSERVANCY

First light on Three Brothers

Another glorious Sierra day in which one seems
to be dissolved and absorbed and sent pulsing onward
we know not where. Life seems neither long nor short,
and we take no more heed to save time or make haste
than do the trees and stars. This is true freedom,
a good practical sort of immortality.

—JOHN MUIR

Half Dome and oak at sunrise, spring

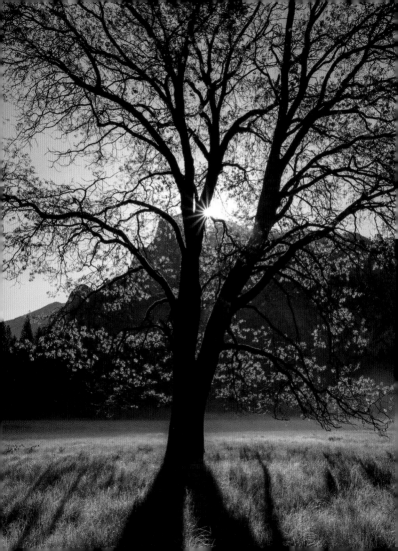

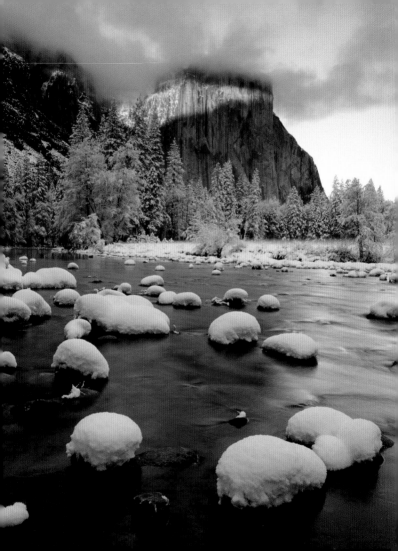

Those who contemplate the beauty of the earth
find reserves of strength that will endure
as long as life lasts.

—RACHEL CARSON

Band of light on El Capitan

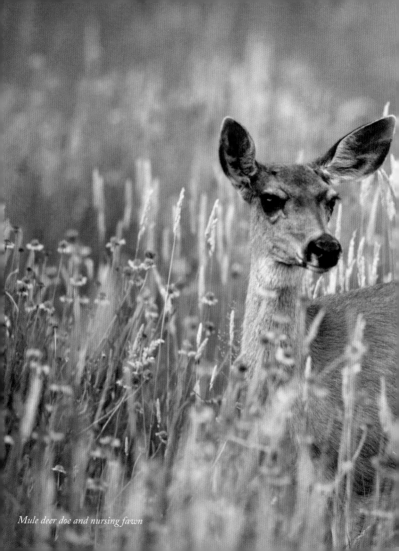

Mule deer doe and nursing fawn

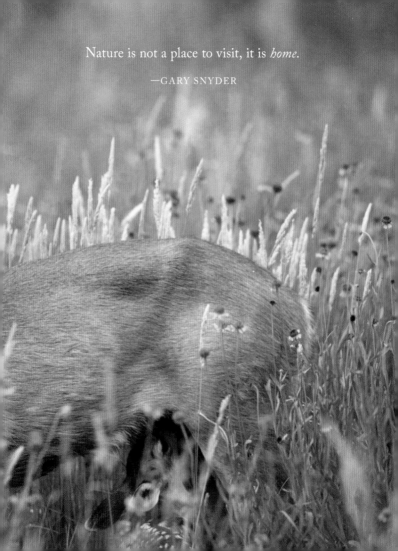

Nature is not a place to visit, it is *home*.

—GARY SNYDER

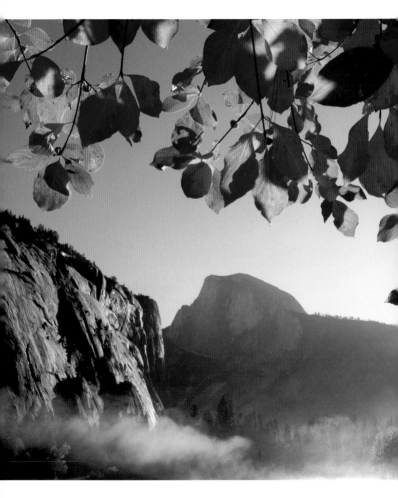

Half Dome and dogwood leaves, autumn

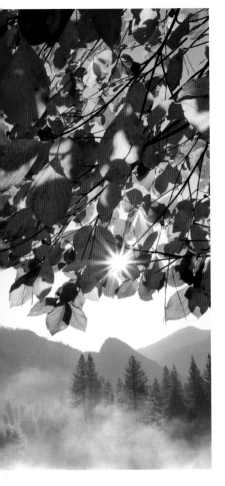

One may lack words
to express the impact of
beauty but no one who has
felt it remains untouched.
It is renewal, enlargement,
intensification. The parks
preserve it permanently in
the inheritance of the
American citizens.

—BERNARD DEVOTO

We are now in the mountains and they are in us, kindling enthusiasm, making every nerve quiver, filling every pore and cell of us.

—JOHN MUIR

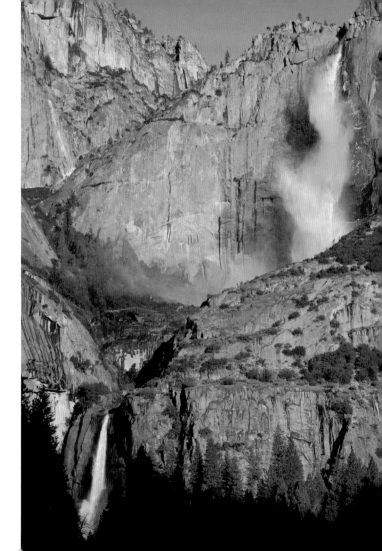

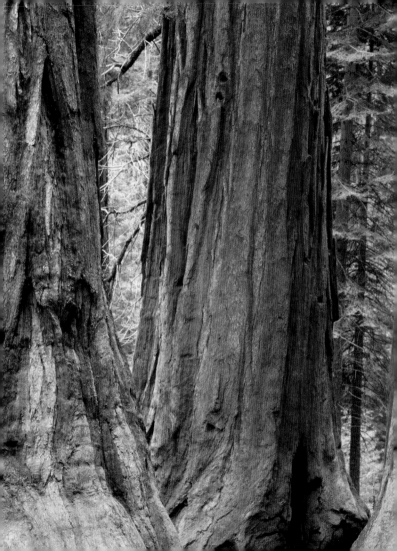

Everything about this ancient race of trees is heroic in scale and cannot be absorbed in a single glance. You must spend quality time among them.

—SHARON GIACOMAZZI

Giant sequoias

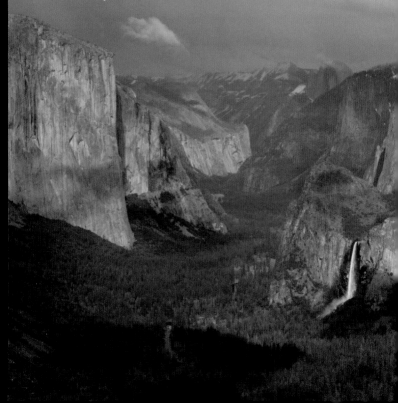

That first vision into [Yosemite Valley's] wonderful depths was to me the birth of an indescribable "first love" for scenic grandeur that has continued, unchangeably, to this hour, and I gratefully treasure the priceless gift.

—JAMES MASON HUTCHINGS

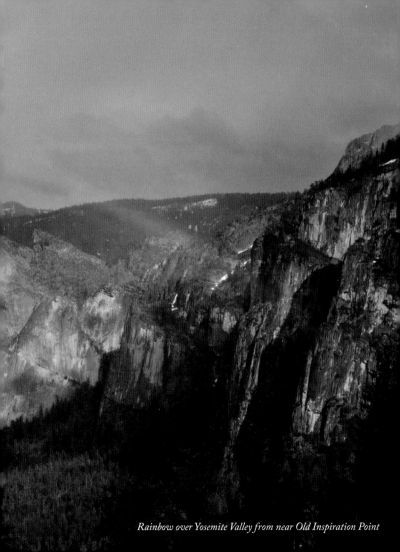

Rainbow over Yosemite Valley from near Old Inspiration Point

The happiness of a mountain day is not a thing,
and cannot be analyzed into so many distinct parts.

Sunset, Tuolumne Meadows

It is a nonmaterial entity to be experienced and
cherished by all the senses.

—CHARLOTTE MAUK

All good things are
wild and free.

—HENRY DAVID
THOREAU

Redbud and the Wild and
Scenic Merced River

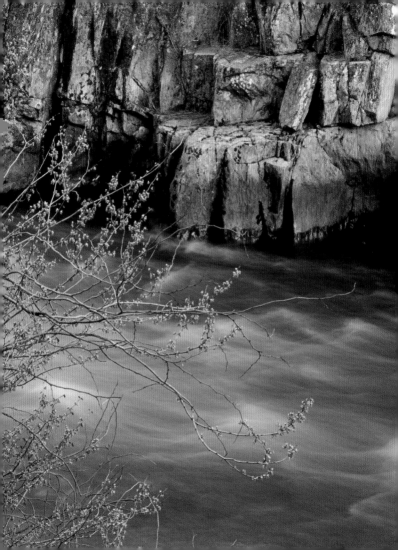

The air up there in the clouds is very pure and fine, bracing and delicious. And why shouldn't it be?— it is the same the angels breathe.

—MARK TWAIN

Clearing storm, El Capitan

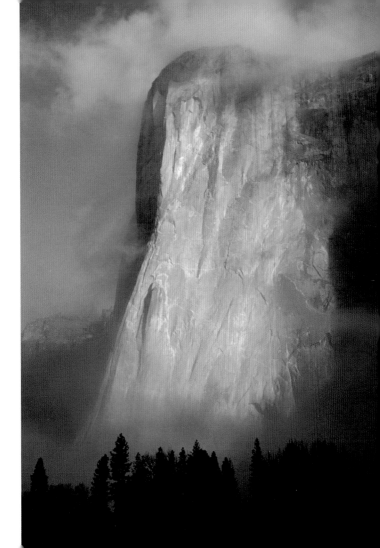

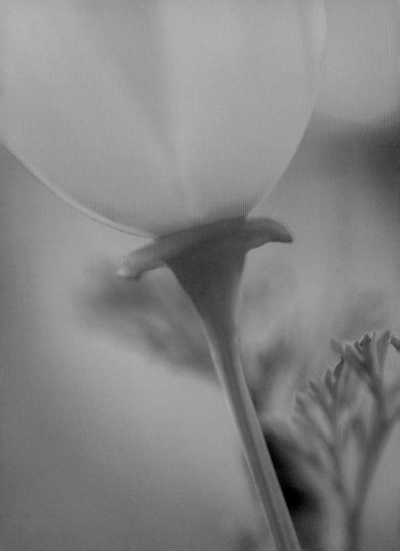

The invariable mark of wisdom
is to see the miraculous
in the common.

—RALPH WALDO EMERSON

California poppy

There is nothing so American as our national parks. The scenery and wildlife are native. The fundamental idea behind the parks is native. It is, in brief, that the country belongs to the people, that it is in the process of making for the enrichment of the lives of all of us. The parks stand as the outward symbol of this great human principle.

—FRANKLIN D. ROOSEVELT

Half Dome and the Merced River

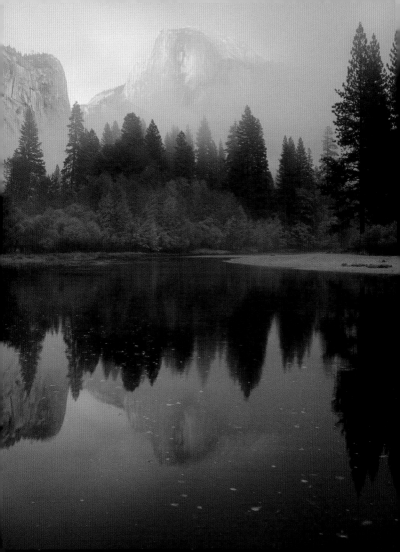

A river seems a magic thing.
A magic, moving, living part
of the very earth itself.

—LAURA GILPIN

Spring runoff, Merced River

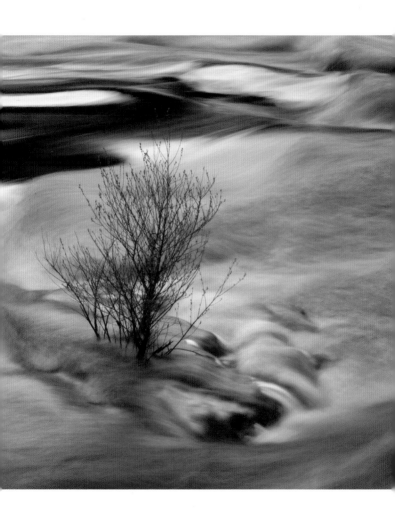

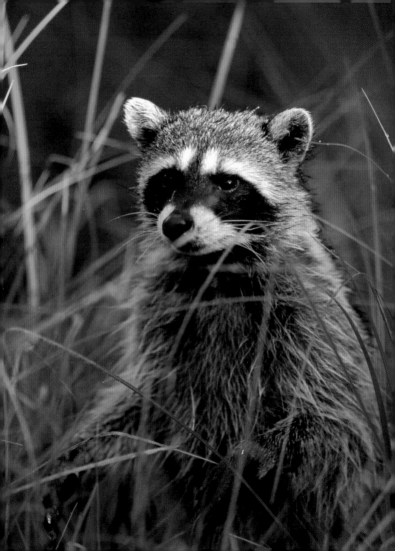

Love the animals, love the plants,
 love everything. If you love everything,
you will perceive the divine mystery
 in things. Once you perceive it, you will
begin to comprehend it better every day.
 And you will come at last to love
the whole world with an all-embracing love.

—FYODOR DOSTOEVSKY

Raccoon

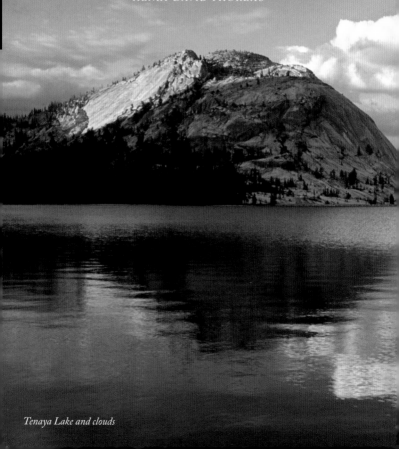

A lake is the landscape's most beautiful and expressive feature. It is earth's eye; looking into which the beholder measures the depth of his own nature.

—HENRY DAVID THOREAU

Tenaya Lake and clouds

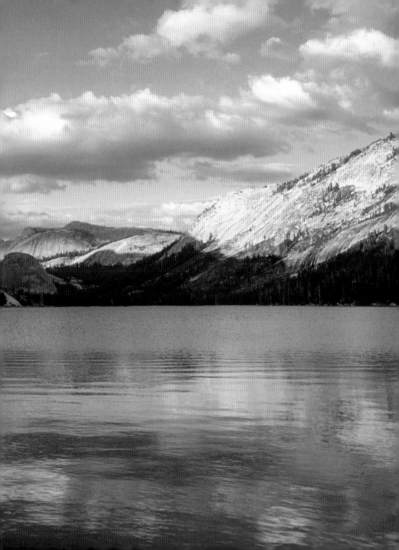

The clearest way into the Universe
is through a forest wilderness.

—JOHN MUIR

Sun, mist, and ponderosa pines

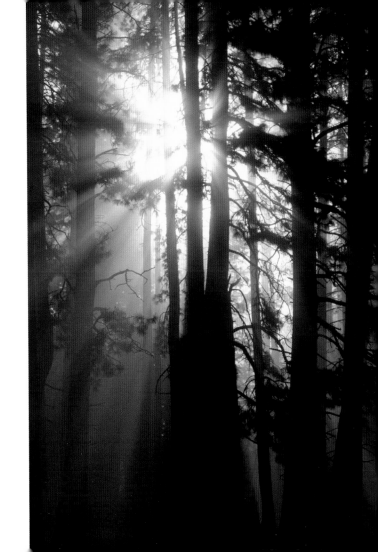

We can't enchant the world, which makes
its own magic; but we can enchant ourselves
by paying deep attention.

—DIANE ACKERMAN

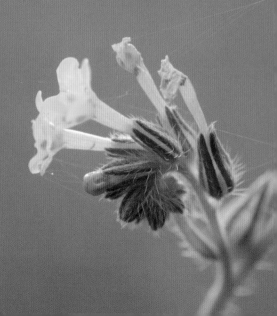

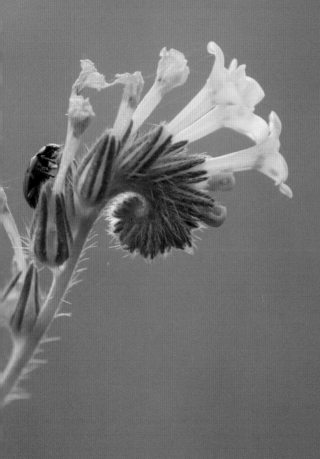

Ladybug on a fiddleneck

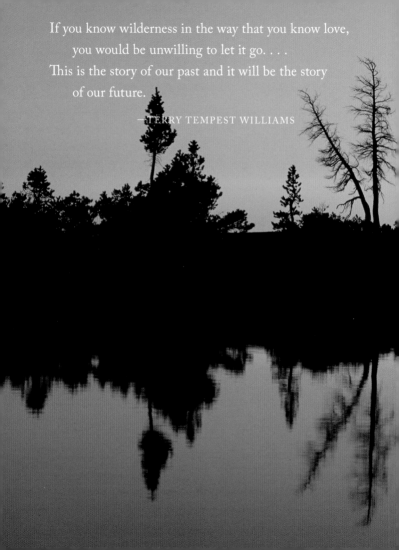

If you know wilderness in the way that you know love,
you would be unwilling to let it go. . . .
This is the story of our past and it will be the story
of our future.

—TERRY TEMPEST WILLIAMS

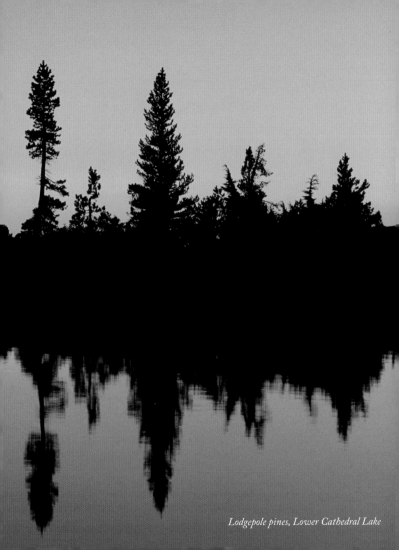

Lodgepole pines, Lower Cathedral Lake

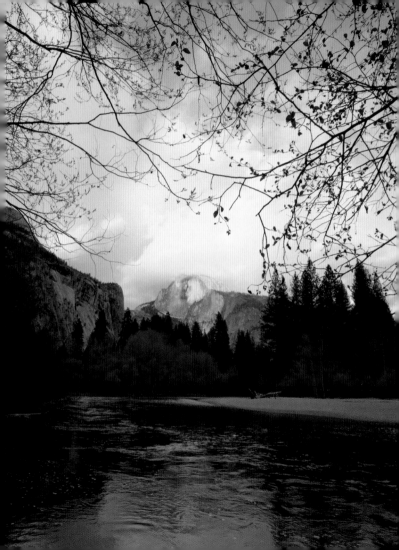

Rushing streams, cold sweet air,
tingling sun and freezing shade,
pine needles, big busy black ants,
content!

—CEDRIC WRIGHT

Half Dome and the Merced River with alder trees

You who have walked otherwise through all the earth, walk gently here.

—PHOEBE ANNE SUMNER

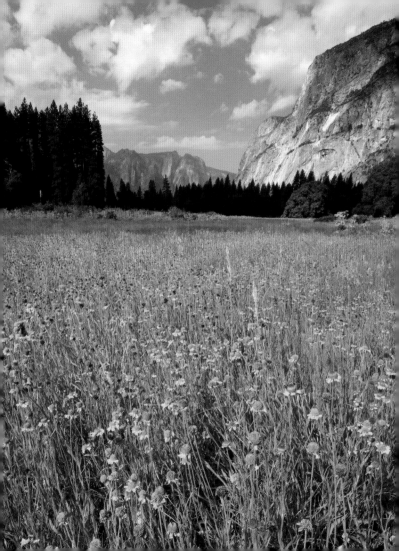

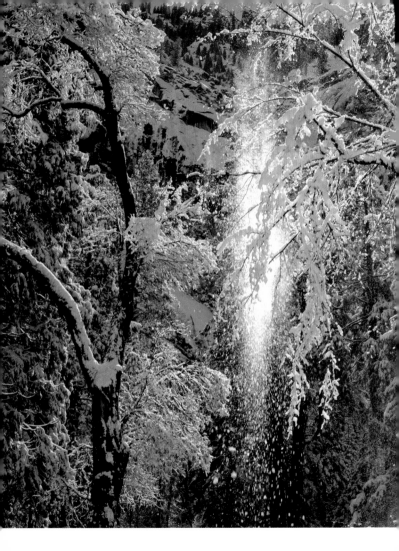

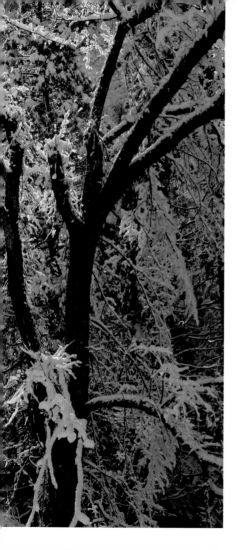

There is a way that
nature speaks, that land
speaks. Most of the
time we are simply not
patient enough, quiet
enough, to pay attention
to the story.

—LINDA HOGAN

Snow falling out of oak trees

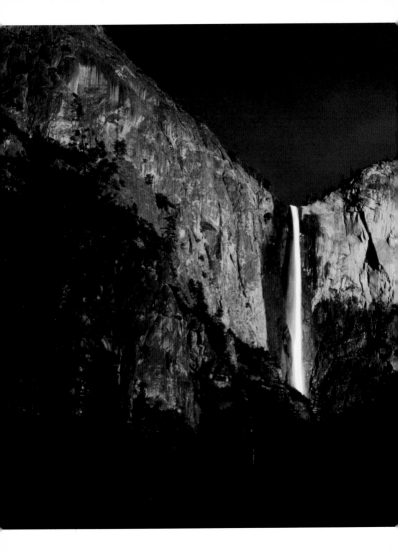

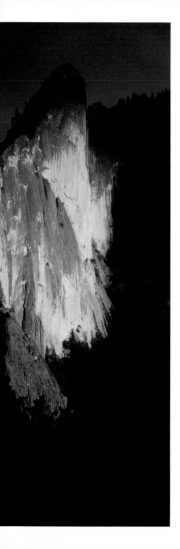

To find the universal elements
 enough; to find the air and
 the water exhilarating;
To be refreshed by a morning
 walk or an evening saunter;
 to be thrilled by
The stars at night; to be elated
 over a bird's nest or
 a wildflower in spring—
These are some of the rewards
 of the simple life.

—JOHN BURROUGHS

Bridalveil Fall and the Leaning Tower

We have nothing to fear
and a great deal to learn
from that vigorous and
peace-loving tribe of trees
that keep producing tonic
essences and soothing balms
for us and that also provide
gracious company in which
we spend so many cool,
snug, and silent hours.

—MARCEL PROUST

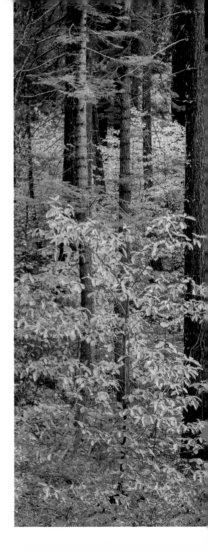

Dogwood and firs, autumn

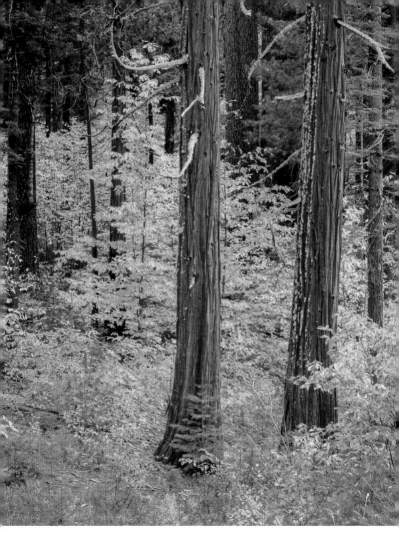

I don't ask for the meaning of the song of a bird
or the rising of the sun on a misty morning.
There they are, and they are beautiful.

—PETE HAMILL

Autumn morning mist

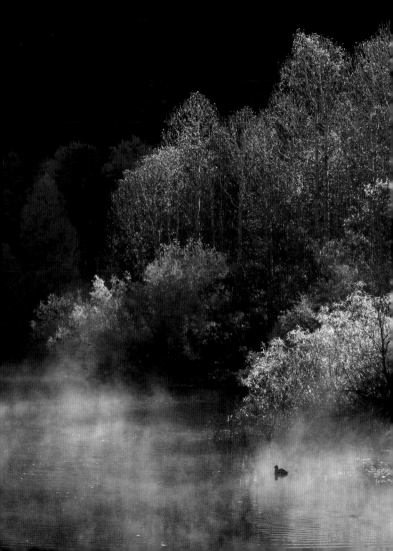

All those who love Nature she loves in return, and will richly reward, not perhaps with the good things, as they are commonly called, but with the best things, of this world; not with money and titles, horses and carriages, but with bright and happy thoughts, contentment and peace of mind.

—SIR JOHN LUBBOCK

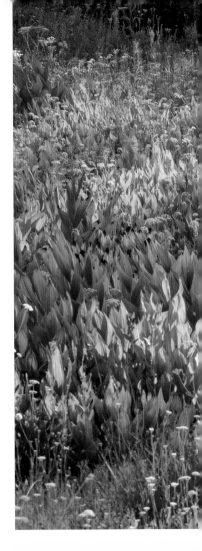

High-country meadow and mule deer buck

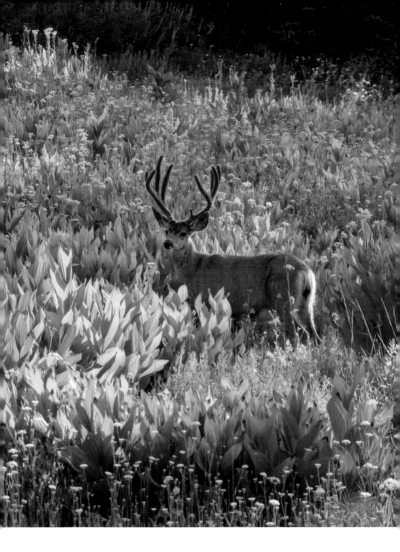

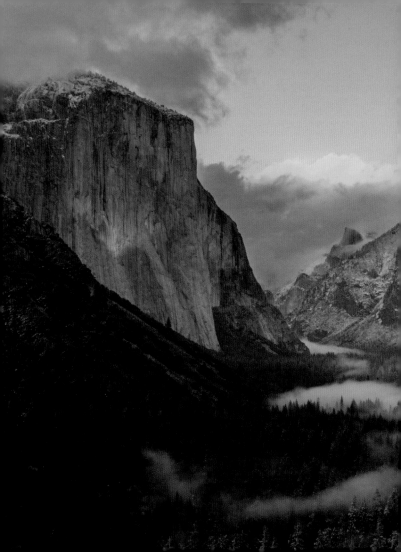

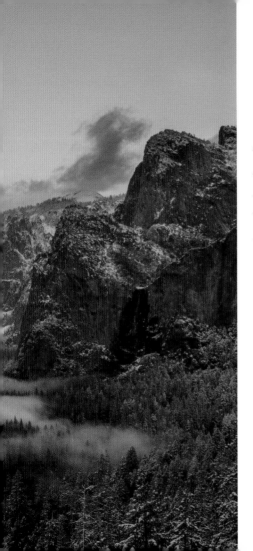

There are few places where reality exceeds the imagination. Yosemite is one of those places.

—SHELTON JOHNSON

Sunset from Tunnel View

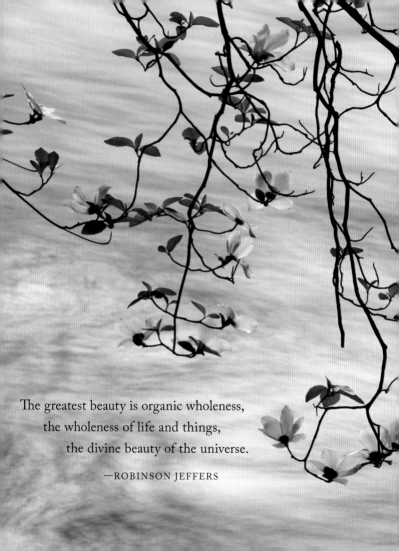

The greatest beauty is organic wholeness,
the wholeness of life and things,
the divine beauty of the universe.

—ROBINSON JEFFERS

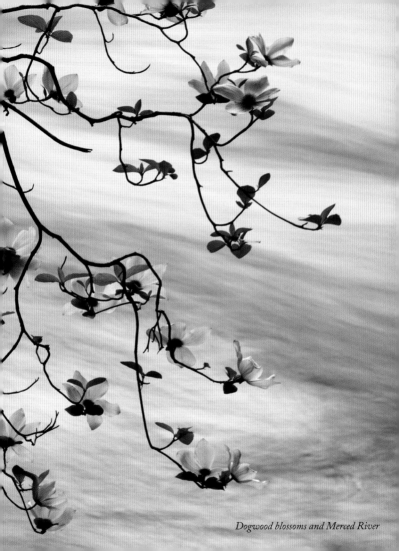

Dogwood blossoms and Merced River

I sometimes watch, like a bird from above,
the pathway of life—observing the connecting
threads and marveling at how childhood
experiences can take hold of the heart, get into
the bones and help shape the life that follows.

—MARGARET EISSLER

Spotted owlets

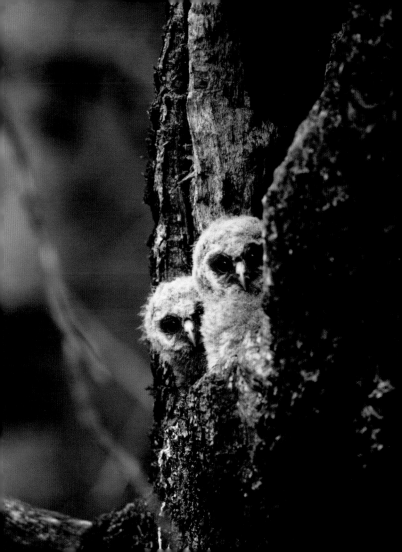

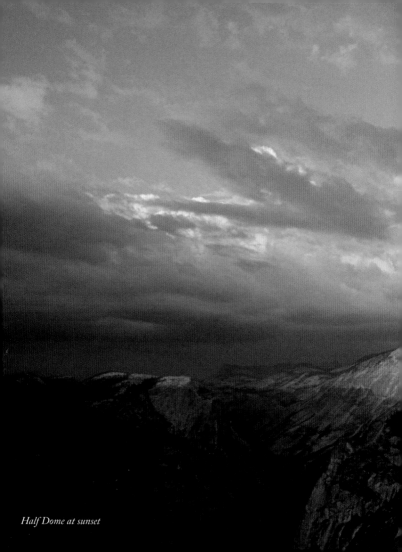

Half Dome at sunset

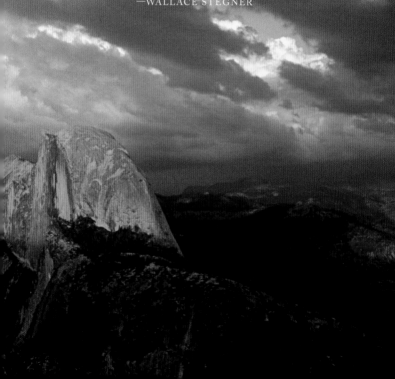

Something will have gone out of us as a people
if we ever let the remaining wilderness be
destroyed. . . . We simply need that wild country
available to us, even if we never do more than
drive to its edge and look in.

—WALLACE STEGNER

Beauty is composed
of many things and never
stands alone. It is part
of horizons, blue in the
distance, great primeval
silences, knowledge of
all things of the earth.
It embodies the hopes and
dreams of those who have
gone before.

—SIGURD F. OLSON

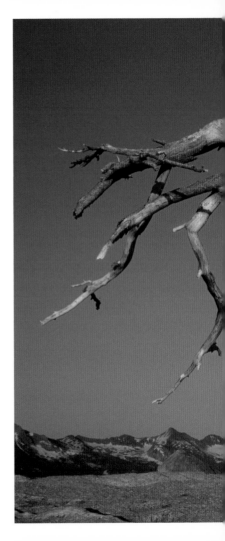

Jeffrey pine snag and rising moon,
Sentinel Dome

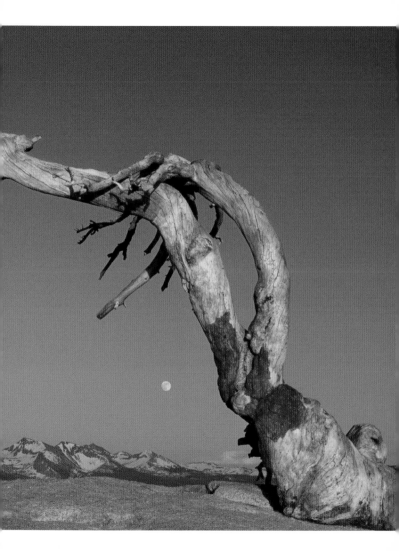

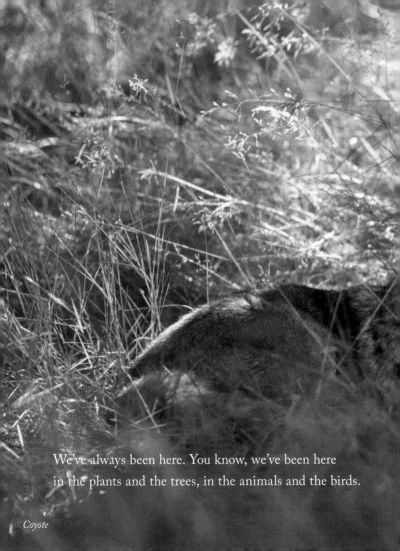

We've always been here. You know, we've been here
in the plants and the trees, in the animals and the birds.

Coyote

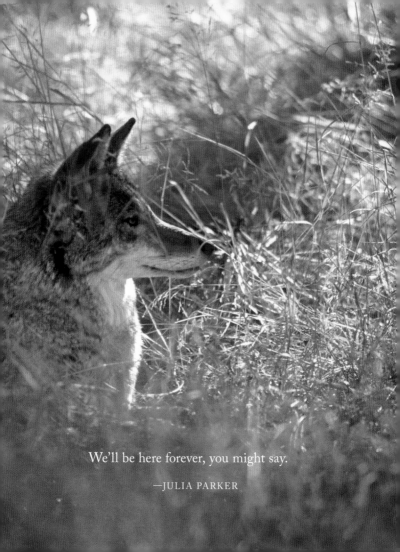

We'll be here forever, you might say.

—JULIA PARKER

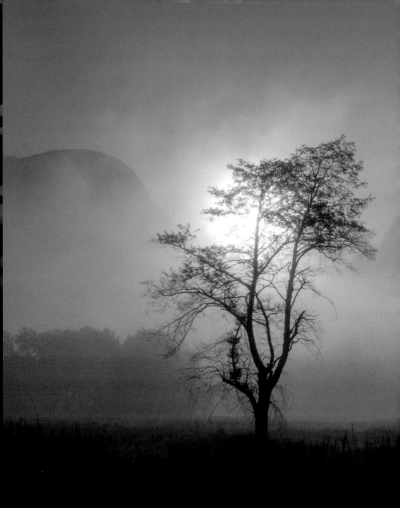

Oak and mist

The most beautiful experience we can have is the mysterious. It is the fundamental emotion that stands at the cradle of true art and true science.

—ALBERT EINSTEIN

"Hope" is the thing with feathers
 That perches in the soul
And sings the tune without the words
 And never stops at all.

 —EMILY DICKINSON

Steller's jay

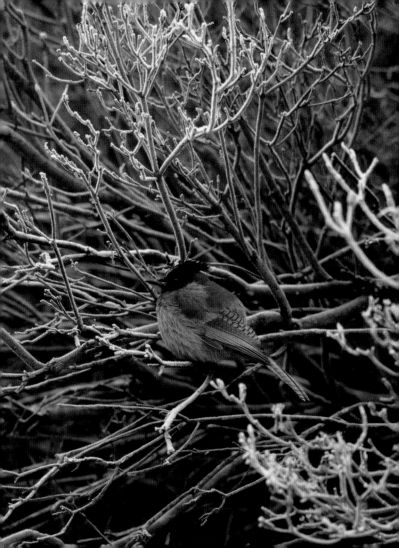

I do not understand how anyone can live
without some small place of enchantment
to turn to.

—MARJORIE KINNAN RAWLINGS

Half Dome and elm tree, autumn

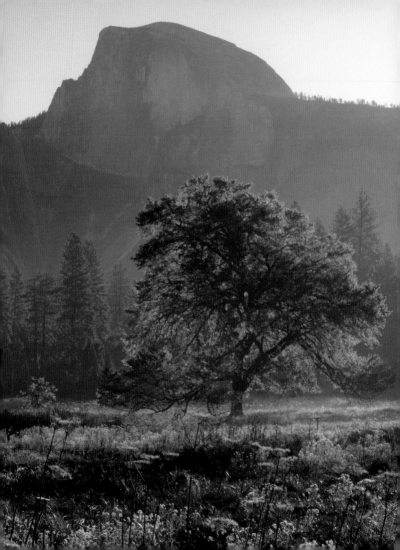

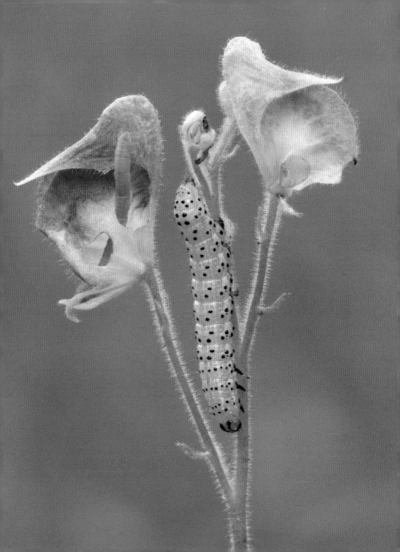

If you will stay close to nature, to its simplicity,
to the small things hardly noticeable, those things can
unexpectedly become great and immeasurable.

—RAINER MARIA RILKE

Monkshood and caterpillars

The love of wilderness is more than
a hunger for what is always beyond reach;
it is also an expression of loyalty to the earth,
the earth which bore us and sustains us,
the only home we shall ever know,
the only paradise we ever need—if only
we had the eyes to see.

—EDWARD ABBEY

Mount Conness from Olmsted Point

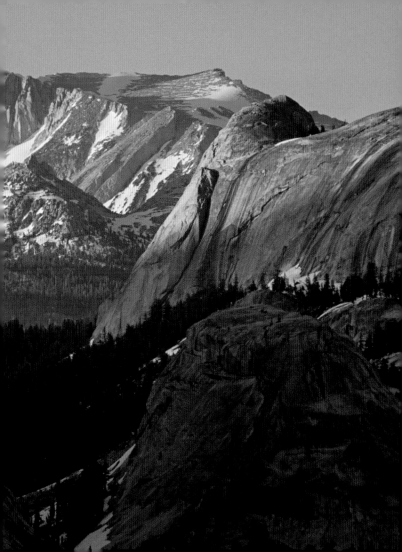

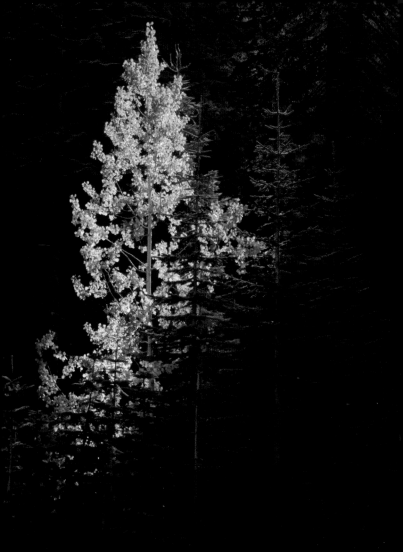

Come forth into the light of things,
Let Nature be your teacher.

—WILLIAM WORDSWORTH

Quaking aspen and white firs

We must begin thinking like a river if we are to leave
a legacy of beauty and life for future generations.

—DAVID BROWER

Merced River, winter

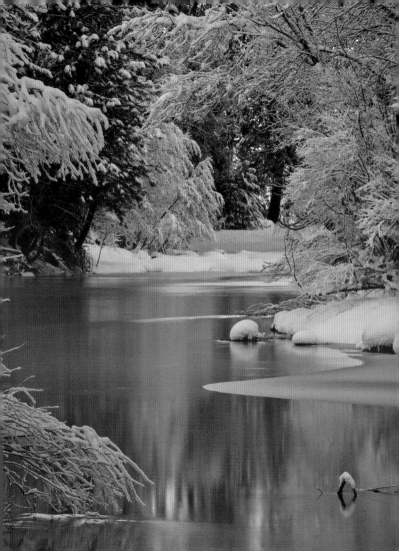

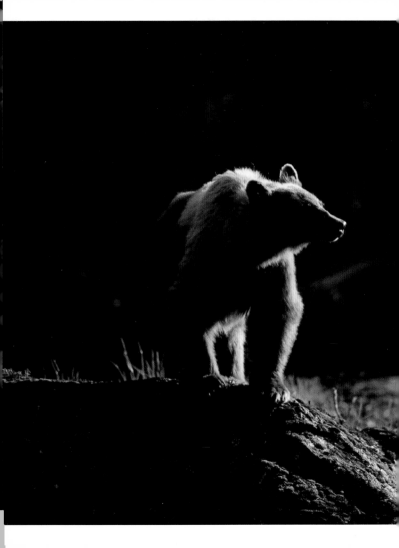

Wilderness itself is the basis of all our civilization. I wonder if we have enough reverence for life to concede to wilderness the right to live on?

—MARGARET MURIE

Black bear

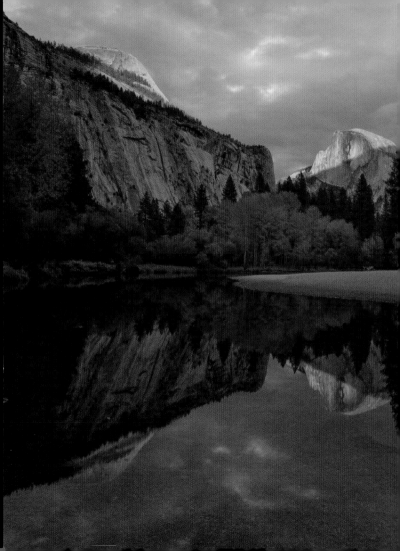

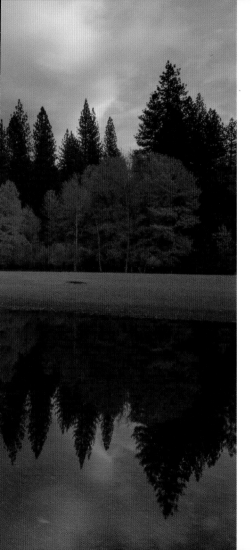

Eventually, all things merge into one, and a river runs through it. The river was cut by the world's great flood and runs over rocks from the basement of time. On some of the rocks are timeless raindrops. Under the rocks are the words, and some of the words are theirs. I am haunted by waters.

—NORMAN MACLEAN

Half Dome and the Merced River at sunset

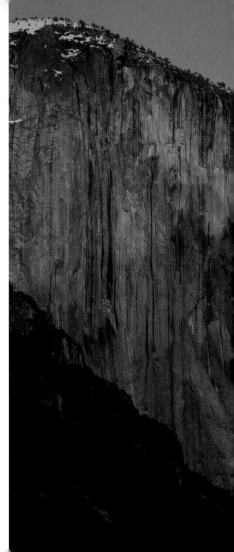

At its best, the national park idea connects us to something larger than ourselves.
To a gigantic living organism or the sweep of eons written in the sculptured granite of a beautiful valley.

—DAYTON DUNCAN

Moon rising between El Capitan and Half Dome from Tunnel View

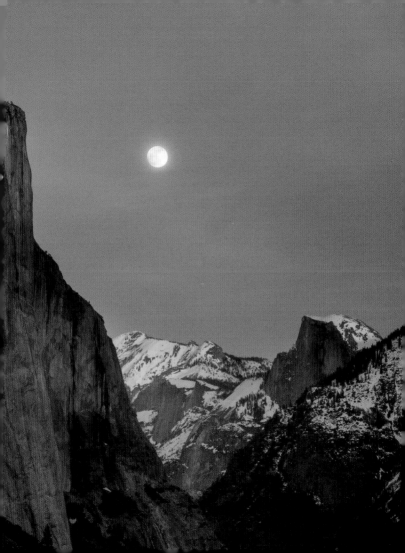

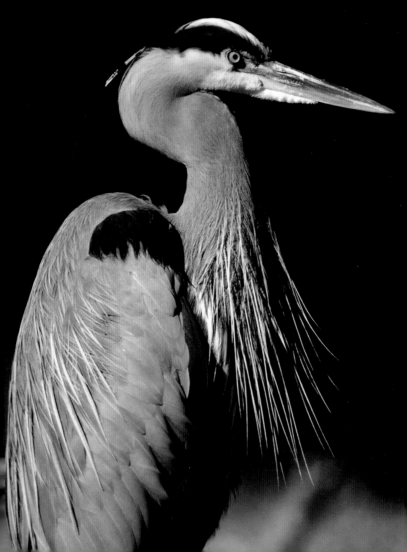

In the end, we will conserve only what we love,
we will love only what we understand, and
we will understand only what we are taught.

—BABA DIOUM

Great blue heron

Ah Yosemite! Thy heart holds the secret
	of the Universe. In spite of ourselves
we are stilled by the spirit of grandeur
	and greatness, until the thrill of the pulse
of the Universe is felt and appreciated.

—CORA A. MORSE

Half Dome and Leonid meteor shower

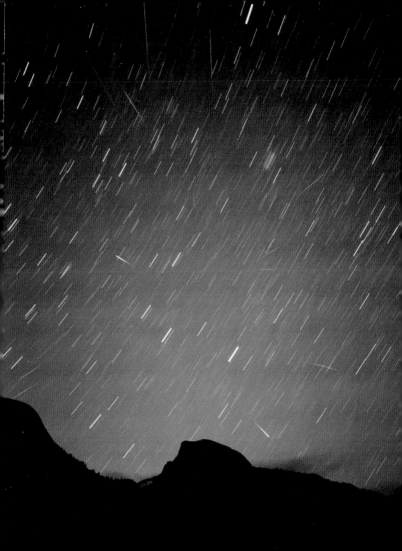

PHOTOGRAPHER'S NOTE

Photography can be its own form of meditation—especially in a place like Yosemite. While exploring the landscape I become attuned to lines, shapes, and nuances of light. I have no thoughts of car payments or book deadlines. For hours I may be aware of only the plants and rocks around me.

Others may experience Yosemite through writing, painting, hiking, climbing, reading, swimming, or just sitting. This national park protects more than rocks and trees. It is a sanctuary for free thought, a place where people can contemplate something more fundamental than asphalt and billboards. What could be more essential?

—MICHAEL FRYE

SOURCES

Abbey, Edward, *Desert Solitaire: A Season in the Wilderness.* New York: Touchstone, 1990. Used with permission.

Ackerman, Diane, *An Alchemy of Mind: The Marvel and Mystery of the Brain.* New York: Scribner, 2004. Used with permission.

Brower, David, as quoted in "A Voice for the Wilderness" by Kenneth Brower. *Earth Island Journal* (Summer 2012). Used with permission.

Burroughs, John, as quoted in *Spring Meditations: Old and New,* edited by Jean Elizabeth Ward. Raleigh, NC: Lulu Press, Inc., 2008.

Carson, Rachel, *The Sense of Wonder.* Copyright © 1956 by Rachel L. Carson. Reprinted by permission of Frances Collin, Trustee.

DeVoto, Bernard, *Mirror of America: Literary Encounters with the National Parks*. Washington, DC: National Park Foundation, 1989. Used with permission.

Dickinson, Emily, as quoted in *100 Essential American Poems*, edited by Leslie M. Pockell. New York: St. Martin's Press, 2009.

Dioum, Baba, excerpt from a speech made to the general assembly of the International Union for Conservation of Nature, New Delhi, India, 1968.

Dostoevsky, Fyodor, *The Brothers Karamazov*, translated by Constance Garnett. New York: The Macmillan Company, 1922.

Duncan, Dayton, *Seed of the Future: Yosemite and the Evolution of the National Park Idea*. Yosemite National Park: Yosemite Conservancy, 2013. Used with permission.

Einstein, Albert, excerpt from "The World As I See It" published in shortened form in a web exhibit by The Center for History of Physics. Last modified November 2004. http://www.aip.org/history/einstein/essay.htm. Used with permission.

Eissler, Margaret, "Parson's Memorial Lodge Summer Series." *Yosemite: A Journal for Members of the Yosemite Association 72*, no. 1 (Spring 2010). Used with permission.

Emerson, Ralph Waldo, *The Portable Emerson*, edited by Carl Bode and Malcolm Cowley. New York: Penguin Books, 1981.

Giacomazzi, Sharon, *Tales and Trails of Yosemite and the Central Sierra: A Guide for Hikers and History Buffs*. Mendocino, CA: Bored Feet Press, 2001. Used with permission.

Gilpin, Laura, as quoted in *The Oxford Dictionary of American Quotations*, edited by Hugh Rawson and Margaret Miner. New York: Oxford University Press, 2006. Used with permission.

Hamill, Peter, *Piecework: Writings on Men and Women, Fools and Heroes, Lost Cities, Vanished Friends, Small Pleasures, Large Calamities, and How the Weather Was*. New York: Little, Brown, 1996. Used with permission.

Hogan, Linda, as quoted in *Listening to the Land: Conversations about Nature, Culture, and Eros* by Derrick Jensen. White River Junction, VT: Chelsea Green Publishing Company, 2002.

Hutchings, James Mason, as quoted in *Yosemite As We Saw It: A Centennial Collection of Early Writings and Art*, edited by David Robertson. Yosemite National Park, CA: The Yosemite Association, 1990.

Jeffers, Robinson, as quoted in *The Oxford Handbook of Religion and Ecology*, edited by Roger S. Gottlieb. New York: Oxford University Press, 2006. Used with permission.

Johnson, Shelton, personal statement, January 2014. Used with permission. Interpretive Ranger, National Park Service, Yosemite National Park.

Lubbock, John, *The Beauties of Nature*. New York: The Macmillan Company, 1905.

Maclean, Norman, *A River Runs Through It*. Chicago: University of Chicago Press, 1989. Used with permission.

Mauk, Charlotte, "Homecoming, 1946." *Sierra Club Bulletin* 32, no. 5 (May 1947). Used with permission.

Mills, Enos A., *Your National Parks*. Boston: Houghton Mifflin Company, 1917.

Morse, Cora A., *Yosemite As I Saw It*. San Francisco: San Francisco News Company, 1896.

Muir, John, *John Muir: The Wilderness Journeys*. Edinburgh: Canongate Books Ltd., 1997. *Another glorious Sierra day . . .*

Ibid. *We are now in the mountains . . .*

Muir, John, *John of the Mountains: The Unpublished Journals of John Muir*, edited by Linnie Marsh Wolfe. Madison, WI: The University of Wisconsin Press, 1979. *The clearest way into the universe . . .*

Murie, Margaret, as quoted in *NOLS Wilderness Ethics: Valuing and Managing Wild Places*, by Susan Chadwick Brame and Chad Henderson. Mechanicsburg, PA: Stackpole Books, 1992. Used with permission.

Olson, Sigurd F., *Reflections from the North Country*. New York: Random House, 1976. Used with permission.

Parker, Julia, as quoted in *River of Renewal: Myth and History in the Klamath Basin* by Stephen Most. Seattle, WA: University of Washington Press, 2006. Used with permission.

Proust, Marcel, *The Complete Short Stories of Marcel Proust*, translated by Joachim Neugroschel. New York: Cooper Square Press, 2001. Used with permission.

Rawlings, Marjorie Kinnan, *Cross Creek*. New York: Charles Scribner's Sons, 1942.

Rilke, Rainer Maria, *Letters to a Young Poet*, translated by Joan M. Burnham. Novato, CA: New World Library, 2000. Used with permission.

Roosevelt, Franklin D., as quoted in *A Companion to Franklin D. Roosevelt*, edited by William D. Pederson. West Sussex, UK: Wiley-Blackwell, 2011. Used with permission.

Snyder, Gary, *The Practice of the Wild*. Berkeley, CA: Counterpoint, 2010. Used with permission.

Stegner, Wallace, as quoted in *Wallace Stegner and the Continental Vision: Essays on Literature, History, and Landscape*, edited by Curt Meine. Washington, DC: Island Press, 1997. Used with permission.

Sumner, Phoebe Anne, "Last Citadel, 1950," *Sierra Club Bulletin* 35, no. 6 (June 1950). Used with permission.

Thoreau, Henry David, *Walking*. New York: HarperCollins Publishers, 1994. *All good things are wild . . .*

Thoreau, Henry David, *Meditations of Henry David Thoreau: A Light in the Woods*, edited by Chris Highland. Berkeley, CA: Wilderness Press, 2002. *A lake is a landscape's most beautiful . . .*

Twain, Mark, *The Complete Works of Mark Twain: Roughing It, Volume 1*. New York: American Publishing Company, Harper and Brothers, 1871.

Williams, Terry Tempest, excerpt from "Statement Before the Senate Subcommittee on Forest & Public Lands Management Regarding the Utah Public Lands Management Act of 1995, Washington, DC July 13 1995." Copyright © 1995 by Terry Tempest Williams. Also in *Red: Patience and Passion in the Desert*. New York: Vintage/Random House, 2002. Used by permission of Brandt and Hochman Literary Agents, Inc.

Wordsworth, William, *The Complete Poetical Works of William Wordsworth*, edited by Henry Reed. Philadelphia: James Kay, Junior and Brother, 1837.

Wright, Cedric, "Trail Song: Giant Forest and Vicinity, 1928," *Sierra Club Bulletin* 13, no. 1 (February 1928). Used with permission.

For Steve Medley, with our thanks, appreciation,
and friendship, always.
—MF & CW

Yosemite Conservancy's Mission
Providing for Yosemite's future is our passion. We inspire people to support projects and programs that preserve and protect Yosemite National Park's resources and enrich the visitor experience.

Library of Congress Control Number: 2014932478

Cover photograph by Michael Frye
Design by Nancy Austin

ISBN 978-1-930238-50-3

Printed in China by Everbest Printing Co. through Four Colour Imports Ltd., Louisville, Kentucky

1 2 3 4 5 6 – 18 17 16 15 14

YOSEMITE
CONSERVANCY.

MIX
Paper
FSC FSC™ C005413

yosemiteconservancy.org